Lankes, His Woodcut Bookplates

Also from Westphalia Press
westphaliapress.org

The Idea of the Digital University

Criminology Confronts Cultural Change

Eight Decades in Syria

Avant-Garde Politician

Socrates: An Oration

Strategies for Online Education

Conflicts in Health Policy

Material History and Ritual Objects

Jiu-Jitsu Combat Tricks

Opportunity and Horatio Alger

Careers in the Face of Challenge

Bookplates of the Kings

Collecting American Presidential Autographs

Misunderstood Children

Original Cables from the Pearl Harbor Attack

Social Satire and the Modern Novel

The Amenities of Book Collecting

Trademark Power

A Definitive Commentary on Bookplates

James Martineau and Rebuilding Theology

Royalty in All Ages

The Middle East: New Order or Disorder?

The Man Who Killed President Garfield

Chinese Nights Entertainments: Stories from Old China

Understanding Art

Homeopathy

The Signpost of Learning

Collecting Old Books

The Boy Chums Cruising in Florida Waters

The Thomas Starr King Dispute

Salt Water Game Fishing

Lariats and Lassos

Mr. Garfield of Ohio

The Wisdom of Thomas Starr King

The French Foreign Legion

Naturism Comes to the United States

Water Resources: Iniatives and Agendas

Designing, Adapting, Strategizing in Online Education

Feeding the Global South

Natural Gas as an Instrument of Russian State Power

Lankes, His Woodcut Bookplates

WESTPHALIA PRESS
An Imprint of Policy Studies Organization

Lankes, His Woodcut Bookplates
All Rights Reserved © 2016 by Policy Studies Organization

Westphalia Press
An imprint of Policy Studies Organization
1527 New Hampshire Ave., NW
Washington, D.C. 20036
info@ipsonet.org

ISBN-13: 978-1-63391-369-1
ISBN-10: 1-63391-369-4

Cover design by Jeffrey Barnes:
jbarnesbook.design

Daniel Gutierrez-Sandoval, Executive Director
PSO and Westphalia Press

Updated material and comments on this edition
can be found at the Westphalia Press website:
www.westphaliapress.org

LANKES
HIS WOODCUT
BOOKPLATES

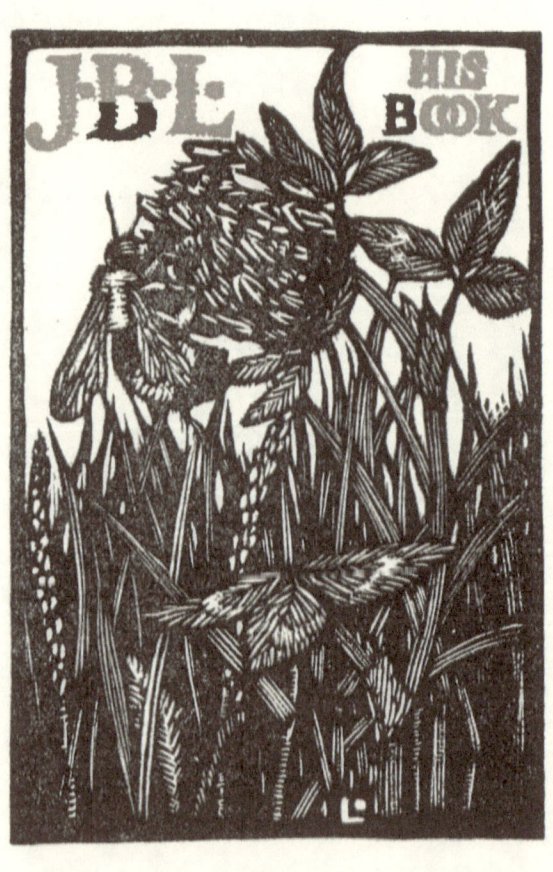

LANKES, HIS WOODCUT BOOKPLATES

by
WILBUR MACEY STONE

Published by Frank J. Lankes,
Beneath the Apple Tree in Gardenville, N.Y.
1922

ILLUSTRATIONS

	Page
Julius Bartlett Lankes	
Julius J. Lankes	6
Emily Comfort Moore	11
Frank J. Lankes	15
Wilbur Macey Stone	19
Edgar Kowalski	21
John Moseley Lankes	25
W. J. Schwanekamp	27
Sophie Yarnall Jacobs	29
Edee Bartlett Lankes	33
Mathew Weimar	35
Carl L. Bredemeier	39
Edward David Hand	43
Francis F. Gregory	45
Robert Link	49

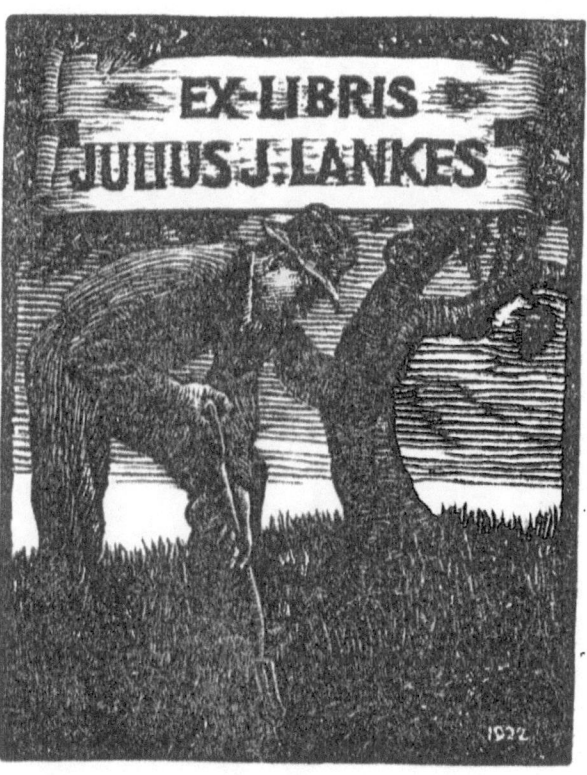

LANKES HIS WOOD CUT BOOK PLATES 🌿 🌿 🌿

IN the early Spring of 1919, a voice crying in the wilderness from "Orchard Avenue, Gardenville, New York" reached me. It was the voice of J. J. Lankes seeking touch with a possible kindred spirit. From that time to this Lankes and I have been in constant heart to heart communion, to my ever increasing delight. Much good paper has been hopelessly spoiled in correspondence, we have met several times face to face, have roamed New York together, visiting print shops and old book stores and bunked together more than once. I am beginning to feel acquainted with Lankes.

When I first knew him he was wasting his soul as a mechanical draftsman to provide bread and cheese, with an occasional pair of half soles for wee worn shoes, for what he described as two human dreadnaughts, not to speak of the faithful wife and mother of the dreadnaughts. In that portion of his time which should have been devoted to recreation, food and sleep, he plowed up the surface of perfectly

good apple tree wood from his ancestral orchard. But oh! to what good purpose that carving and routing was done! From these hacked and tortured surfaces were pulled prints to delight the eye and heart. The subjects of these prints were mostly from the homely environment of the apple orchard and its neighboring village scenes. The blocks on which they were cut were of all thicknesses and shapes and many so thin as to have perished in the hard test of printing. Later Lankes learned that there was such a dimension as "type-high", then it was smoother sailing.

Of course Lankes had had art training, in Boston and Buffalo, and had made drawings galore before he attempted wood engraving. His first block was less than two by three inches in size and on it he carved a duck, that is he says it is a duck, flying over a cat-tail swamp. The cat-tails are excellent but the knife would slip on the duck. I can sympathize with him. I have tried to carve a duck. I recommend a platter with a very high edge.

Since that duck made its erratic flight in 1917, Lankes has been acquiring skill in the handling of his tools and has been developing and per-

fecting his technique until now he has a distinguished individuality of touch and has produced a quantity of blocks, prints from which are esteemed by those competent to judge them and admired by all lovers of the graphic arts. Examples of his work have found permanent lodgement in the collections of many of our most prominent museums and libraries, and in the portfolios of numerous collectors.

One splendid and hopeful feature of Lankes' attitude toward his work lies in the fact that he is in a chronic state of dissatisfaction with it. This attitude of mind perhaps does not always react on his immediate human surroundings in the most delightful manner but it does keep him in a properly chastened spirit, forever striving for better and higher attainments. But with all this inward seething, his character is sunny and most companionable. Also, obviously, being a keen self-critic, it is always a delight to hear his comments on the work of others. Generous in praise of sincerity and appreciative of ability, his comments on shoddy work and pot boilers, even by recognized masters, cut to the bone, and then even a tyro can see how weak and shallow the work is.

A critical survey of Lankes' work during the last few years discloses marked growth in ability to interpret nature in her more subtle moods and nuances. From very early in his wood cutting career he evinced a keen appreciation of and developed ability to render atmospheric and lighting effects with great charm. The variations of the seasons, the differentiation between the sky tones of morning, noon and night were well interpreted. His later work shows increased skill in these subtle renderings and are an ever increasing joy to the admirer of fine prints.

Since his early days of struggle for the mastery of his chosen form of expression, many automobiles have gone over the bridge and much good apple tree wood has been butchered to make a Lankes wood-cut. But now-a-days the blocks are cut with decision and precision and toward a difinite and preordained result.

However, our title page has been, so far, misleading. This essay purports to be about Lankes' book plates and therefore it may be in order to give this feature of his wood engraving some attention. Of course, in conformity with time-hallowed custom, one should begin a story of this kind with the ancient history of the book-

EMILY COMFORT MOORE

EX-LIBRIS

plate, explaining what these little scraps of engraving are for, with reference to that patriarch of all bookplates, found in a volume of 1470 in the Carthusian monastery of Buxheim. One could then review Lord de Tabley's volume with his old fashioned classification of the different armorial styles, which are of interest to the antiquarian only and, after wading through the formidable bibliography of the general subject, arrive at Allen's volume on American bookplates. But even that volume is now about a generation old, albeit still the standard work on the subject.

But bookplates are now recognized as an established adjunct to our literary life and every well established library has at least one. Some people, in their rash modern extravagance, have several bookplates, each of a character adapted for some particular collection or branch of their libraries. But such are mere dilettantes and inconsiderable herein. Others, often owning no personal bookplate, collect the bookplates of others, a most pernicious habit and, lacking a plate of their own for exchange, a habit requiring the attributes of a buccaneer for its successful pursuit. One of these collecting pests, of whom

I know, even burst into rhyme on the subject and boldly declared:

> "My house is full of bookplates,
> They're hung upon the wall;
> You'll find them in the attic
> And tacked up in the hall.
> If there are plenty of them
> I care not for their looks;
> I paste them 'round most anywhere
> Except within my books."

Perhaps this horrible example may prove a timely warning to the weakminded. For most rightminded, sensible people one bookplate suffices and goes into all their books irrespective of subject or binding.

It may be fitting at this point to define a bookplate. The best definition I know is "A decorative name label, adapted for pasting onto the inside front cover of a book, to denote the ownership of the book." "A decorative name label" would indicate that the name was of first importance, therefore the lettering on a bookplate should receive a full and early share of attention and not be an afterthought appended to or jammed into a design or picture. Many of Lankes' bookplates measure up most satisfactorily to this primary rule, a few do not.

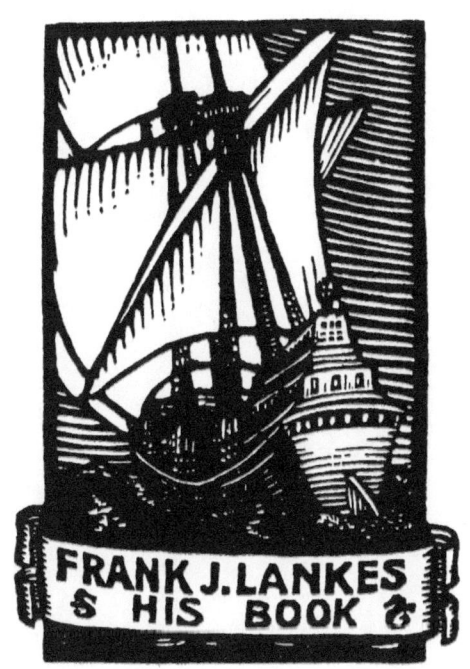

Also, in justice to our maker of bookplates, and to the vast army of bookplate makers to which he is so recent a recruit, it should be and is herewith remarked, that the maker of a bookplate is rarely the sole inventor thereof. He may contribute all the artistic excellence, but the prospective owner usually has a finger, sometimes both hands, in the pie and is therefore coconspirator with the artist. Wherefore, when you see a bookplate design which fails to please you wholly, don't curse the artist out of hand, but think what pressure may have been brought to bear on him while he was in the throes of production and—make allowances. You can however fairly assume that whatever is delightful and pleasing in the design, composition and execution may be laid at the artist's door, while whatever is incongruous and gauche was contributed by the one whose name is inscribed so indelibly thereon.

So, after these further delays, let us to the bookplates. His first wood-cut plate, that for Emily Moore is distinctly a decorative name label, and carries suitable bookish suggestion, but woe to any one who thus mixed up *my* precious volumes with the inkstand and candle

grease! The lettering of this plate is, in character, beyond criticism and the whole is an excellent conventional design, to which none could take offence.

Frank Lankes, the artist's brother and publisher, is of a roving temperament, has been to sea and knows the smell of oakum and brine. What more fitting than the old galleon, outward bound, bowling along before a good breeze. The name ribbon is suitably tied to the design and the result is a plate which one would enjoy meeting in cherished volumes.

While there is sprightliness and vivacity in a number of Lankes' bookplate designs, the next one for "W. M. S.", is the only example I know which evinces definite humor. The "old guy" pawing over the dirty derelicts of the sidewalk box in front of the old bookshop is very provocative of smiles, broad smiles. The fact that it is not a halfbad portrait of its owner adds to the charm and humor. My only criticism is that the artist was not included in the picture for in very truth he stood beside me. This plate is reminiscent of desultory wanderings together amid the purlieus of literary and artistic junkdom. Another

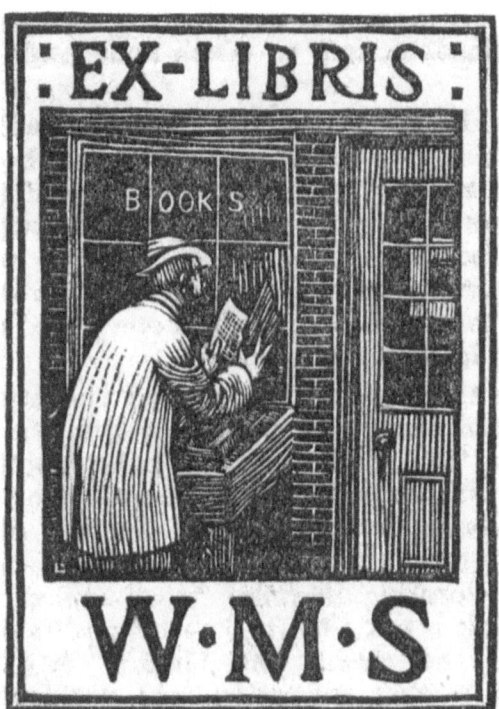

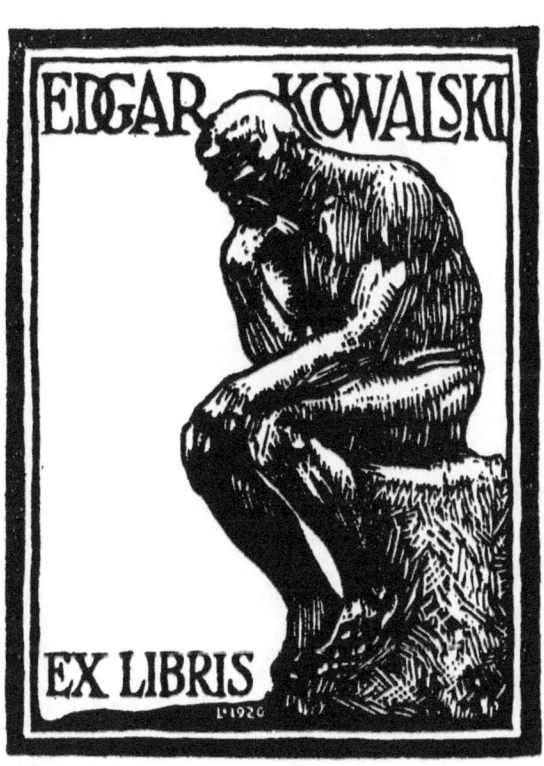

touch of sly humor was the inclusion of the bookshop door, for the entrance to such a den as is pictured in the plate is an irresistible temptation to both artist and plate owner, who are guileless flies in the presence of the spider and his web.

The "J. B. L.", design, the frontispiece, was done for the first-born and heir to the Lankes estates. The small boy who owns this plate doubtless fails to appreciate its subtle significance but he cannot but respond with satisfied feelings to its presence in his books. The special field of bookplates for children is a difficult and dainty one. It is easy to blunder therein and to sow thistles instead of clover. In this first design for a child our artist could not have been more felicitous. Clover honey is unsurpassed, and well-selected literature for the rising generation is correspondingly rich in vitamines. Also, and of course, the moral lesson must be obtruded here to bedevil the poor child. For this we hark back to dear old Isaac Watts who gave to the world those immortal lines:

> "How doth the little busy bee
> Improve each shining hour,
> And gather honey all the day
> From ev'ry opening flow'r."

There are three other verses, which carry the sting but most of us have forgotten them. A modern philosopher caustically remarks "Yes, the poor bees work early and late and the farmer grabs the honey."

In the plate for Edgar Kowalski we have symbolism again and of a somewhat more obvious character, the figure being an interpretation, in black and white, of Rodin's "Thinker", altogether a dignified and acceptable design for a bookplate. Furthermore, it is characteristic of the owner and fairly reflects his cherished attitude of mind.

The Buddy Lankes plate is obviously for "little brother" and is a charmingly simple thing, almost entirely in silhouette. It shows a spring morning landscape with scant foliage, the young tree, bursting into leaf and the birds into song, all daintily symbolic of childhood. This plate "hangs together" excellently, the lettering is consistent and is at one with whole design. Of course the artist persists in maintaining that this plate was done for a Christmas present and that the landscape is a bleak and snowy one, the few leaves on the trees being

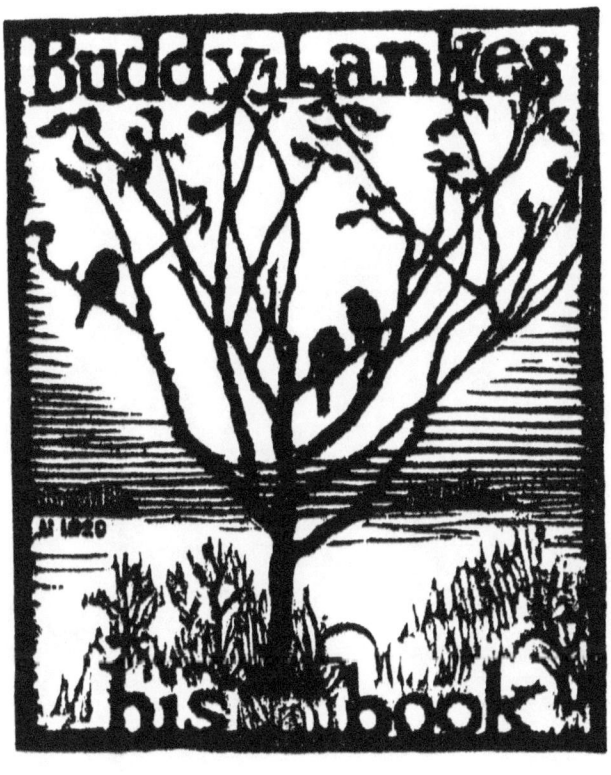

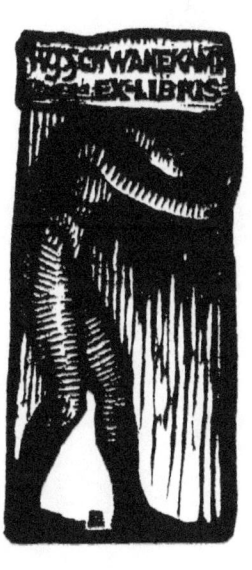

"left-overs" and that the birds are shivering with the cold. Perhaps he is right but how much more pleasing my interpretation! Incidentally, Spring or Christmas, which ever it may be, won appreciation at the sixth annual exhibition of the American Bookplate Society in 1921, where it received "Honorable Mention."

The Schwanekamp design gives me the backache and one copy in my collection (yes, I am one of the reprehensible gang—now it's out!) is all I care for. I would not like to meet it every time I opened a book. Just the same it is an excellent bit of wood-cutting and highly pleasing in technique. And here again, in this plate we have an underlying symbolism touching the owner, but we must not publish to a cold and ribald world all the idiosyncracies of those kindly folk who have permitted the use of their plates to adorn this tale.

In the Sophie Yarnall Jacobs plate we have one of Lankes' charming landscapes including a characteristic summer sky. The rendering of clouds, light and fleecy, by broad-gage cuts is a continuous marvel to me and the results always a delight. Lankes accomplished this feat of legerdemain early in his wood-cutting career

and has steadily enriched the effects thereof with added subtleties. In this design the Lombardy poplars against the sky form a bold silhouette, while the cottage in their shelter is almost lost in the gloom. The pool of water in the foreground across which the shadows of the poplars fall glows with the reflected light of the summer sky. But—the appending of a name to this design does not make it a bookplate within the terms of our definition. One has a feeling that its present use was an afterthought and that the design and the name label are unrelated.

In the plate for Edee Bartlett Lankes, the mother of the two "dreadnaughts", the tall timothy provides an acceptable hunting ground for the fat grasshopper, who, if his upward progress continues, will soon be out of the picture. This is a delightful "Nature" plate and the lettering is pleasing, out of the ordinary and "blends" most excellently with the design. This plate is quite in the same spirit as that for J. B. L., and both may be rated as highly successful examples of this dainty art. Mrs. Lankes protests that the happy-go-lucky grasshopper, while possibly symbolic of her ambitions, is hardly representative of the actual life and

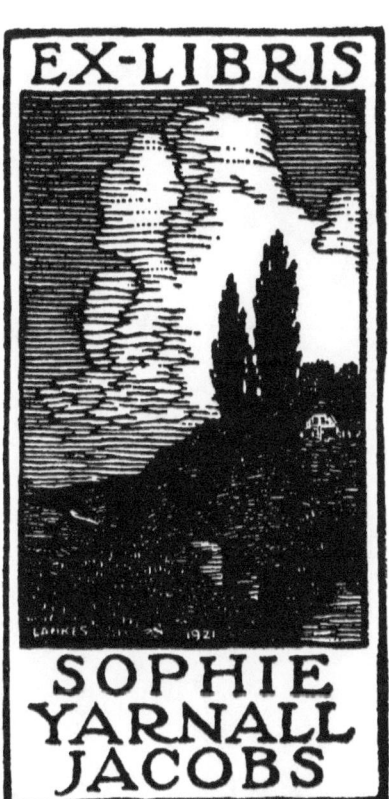

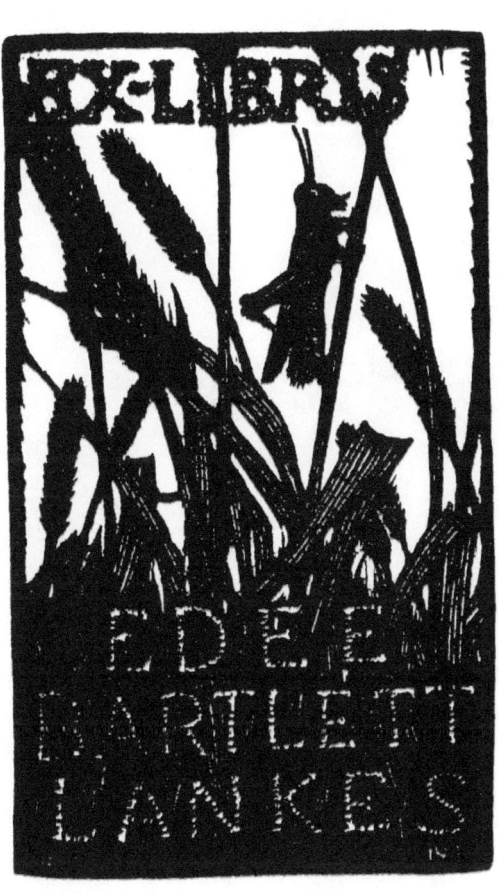

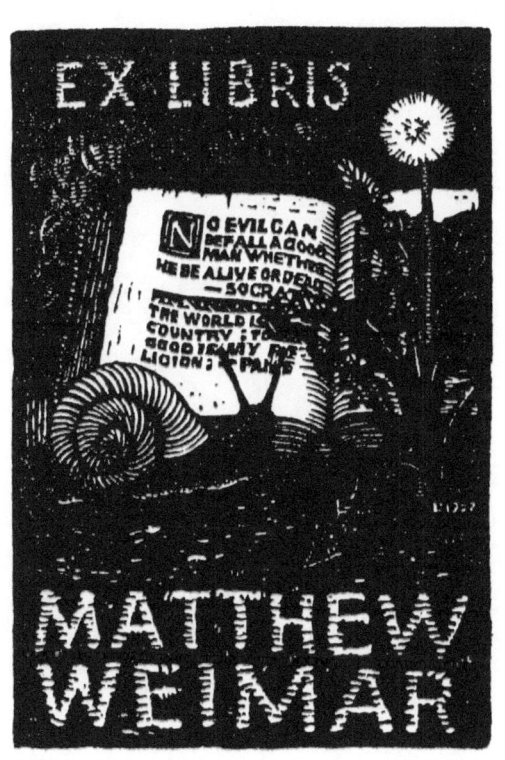

labors of the chatelaine of an artist's chateau. This design was one of five examples of Lankes' bookplates shown at the seventh annual exhibition of the American Bookplate Society in 1922 and was awarded "Honorable Mention" by the jury.

The character of the Matthew Weimar design strikes a note quite different from that of any of the other designs here presented. The style harks back to some of our earliest examples of wood engraving in which the major portion of the printed surface is black and only the high lights of the design picked out with the graver. It is rich in color and beautiful in design and feeling. The rendering of the snail's shell is very satisfying and his horns are alert as he seeks knowledge from the old volume among the weeds. It is evidently late afternoon, as indicated by the "four o'clock." Of course book-lovers do not cast their literary pearls before swine nor their precious volumes to the snails, but some things are permissible in a decorative design which would be censurable in the cold light of day and actuality, so we accept this trespass with pleasure in the enjoyment of the performance.

The Carl Bredemeier design was of slow growth. I have in my portfolio five different states of this plate. It was first designed and cut in a much larger size and this first block discarded for the smaller one which is reproduced here. This plate is reminiscent of the Kowalski design, but only in the pose of the figure. Here our studious man is seated in a commanding position, precariously near the edge of a cliff and seems quite oblivious to the beauties of sky and landscape which are spread before him, as well as to the dangers of the yawning chasm at his feet. The volume on his knees is all-absorbing. This plate is of unusual shape and is a welcome deviation from the standard rectangular.

The David Hand plate is another juvenile, for a boy of ten, who loves his pony and the country lanes as well as his books. So the artist has carried the spirit of field and sky, boy and pony into his bookplate. Silhouetted trees against what we have come to look upon as a truly Lankesian sky are admirably balanced in the design and we are grateful to the artist for this contribution to the not large record of really beautiful bookplates.

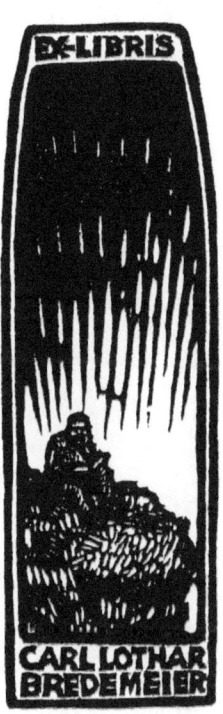

The Francis Gregory plate is a typically bookish one. The venerable scholar, round-shouldered from much pouring over ancient tomes, is slowly deciphering the intracies of a huge volume in black letter, by the dim illumination of a single fat candle. This design is well-framed, has distinguished bold lettering and cannot but be a pleasing mark to encounter in the books of one's library. Without knowing anything of the owner's tastes or his attitude toward the masterpieces of literature, it has been my observation that very often the owner of the ultra-bookish bookplate is inclined to the frivolous and the ephemeral in his choice of books. We can only hope that this instance is an exception to the rule.

For our tailpiece we have a cocktail, not with any intention of further smudging that much-bedraggled eighteenth amendment, for our cocktail is quite innocuous and definitely non-alcoholic, but to illustrate the small boy owner's attitude toward life. Master Bobby is a cocky chap living with his fond parents in one of the subsidiary Boroughs of Greater Gotham and is being inoculated slowly but surely with a love

of books and pictures. Prints of this wee block, pasted into his books, is one means to that end.

The artist's own plate, while preceding all others save one in this volume, is just naturally the latest one he has cut. Another instance of the shoemaker's child. This plate is perhaps the most symbolic of any here shown. "Dig" is the keynote of our artist's life. Digging has been his occupation from infancy and has brought him thus far on the rocky road toward success. The apple tree in the background supplied the wood for his first blocks; its back is bent as is that of the digger's. The apple tree is reputed to have been the tree from which our first mother, Eve, plucked the fruit which opened up the stony path of knowledge. Also the digger is supposed to be seeking something other than worms for bait as he has scant time for fishing.

While the prints in this volume do not include all the bookplates Lankes has made, they do include nearly all and afford an excellent and comprehensive exhibit of his work in this field. When one has them all spread out for comparison, they give a pleasing sense of variety in subject and treatment, although all fall well

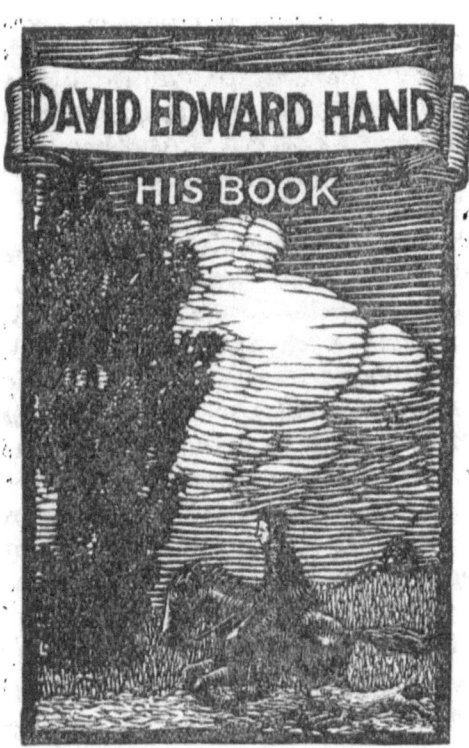

within the desired simplicity best adapted for bookplate design and well within the scope of the medium in which they are presented. And be it noted, that medium is essentially the white line of the wood engraver in all its purity, beauty and force. These designs were not thought out nor drawn in the terms of the pen-draftsman and then the surrounding wood cut away. They were conceived and executed in the essential terms of the wood-cutter, white lines and masses on a black ground. There may be no particular sanctity or virtue in the white line on a black ground over the black line on a white ground, but the former has charms, which, when used by a master, satisfy and often thrill us, where the line drawing leaves us cold. Only two of the designs here included smell of the lamp and they are the earliest. Not that a whiff of kerosene is taboo in a bookplate, quite the contrary, but it is not in the normal vernacular of our artist. He is an out-of-doors man. True, the "Thinker" of the Kowalski plate might be noted as another exception, but all of the others smack of the open, either orchard, field or sea. Even in the W. M. S. design we are still in the open, albeit pounding the pavements.

Also the designs run much to the "unconsidered trifles" of field and hedgerow and the beauty and grace of God's little creatures are presented most sympathetically for our admiration and delight.

Not only do these prints give us commendable examples of both bold and dainty wood engraving, but they are obviously works of Art, and we may use the capital A with a feeling that it is legitimate. The composition in these designs repays study. For instance in the frontispiece the right leg of the man, the tree trunk and the spade all slant in the same general direction, intensifying the thrust of the spade. The Frank Lankes plate has excellent balance and is a satisfying example of well-arranged space filling. The Buddy Lankes design is a simple one but not by any means an empty one, nor was that simplicity arrived at by accident or negligence. In so simple a design each tool cut must mean something and contribute to the general result. The little tree is "off center", but the design as a whole is balanced. The name lettering almost grew on the tree and the words at the foot of the design are a real part of the underbrush. The J. B. L. plate presents a broad variety in the

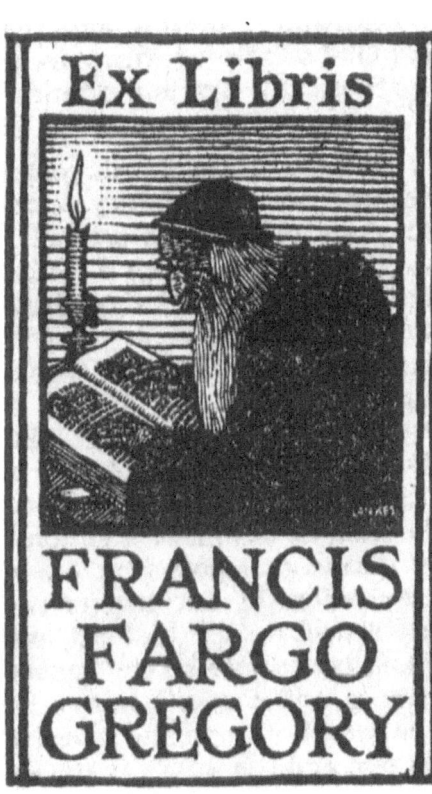

character of the cutting, each feature being interpreted in a particular manner; the grass blades by long sweeping grooves, the stems by short cross cuts, the plantain by round deep digs and the clover leaves by lines which bring out their anatomy, with a fine suggestion of color. Then lastly, the bee's wings are real gossamer and as translucent as gauze.

And so we might point out the delicate and subtle beauties of other plates but surely a few discoveries should be left to the gentle reader, so we desist. And, after all has been said, written, analyzed and explained there remain the wood-cuts, gaze on them!

www.ingramcontent.com/pod-product-compliance
Lightning Source LLC
Chambersburg PA
CBHW020710180526
45163CB00008B/3026